T2-BVP-768

D1441492

This Book Belongs To:

he yelled, I
screamed... she pulled
y hair!
3305233625932
p 10/16/15

elled. I Screamed...
She Pulled my Hair!

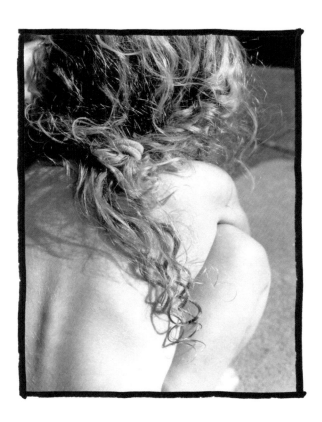

story & images
by
Tracy Leshay

againAGAINbooks

Los Angeles

She Yelled, I Screamed... She Pulled my Hair!

First Edition

Story by Tracy Leshay

Photographs (Olympus OM-1 35mm SLR) by Tracy Leshay

Graphic design by James Renald & Tracy Leshay

www.tracyleshay.com

Published 2015 by
again AGAIN books
Los Angeles, California
www.againagainbooks.com

Text Copyright © 2015 by Tracy Leshay
Photograph Copyright © 2015 by Tracy Leshay
All rights reserved. No part of this book may be reproduced, distributed, or transmitted in any form or by any means,
or stored in a database or retrieval system, without the prior written permission of the publisher, except for the inclusion of brief quotations in a review.

Hard cover: ISBN# 978-0-9899988-3-3
E-Book: ISBN# 978-0-9899988-8-8
Paperback: ISBN# 978-0-9899988-0-2

Frank Guy Lynch's *Satyr* Photographed by Tracy Leshay with many thanks to the Sydney Royal Botanic Garden

This book is a work of fiction.

Non-Digital Copies Printed in U.S.A.

Thank You Jon.

For Phoebe & Audrey...
to share

One summer the sun cast a nasty, hot spell.
We were under the weather and not at all well.

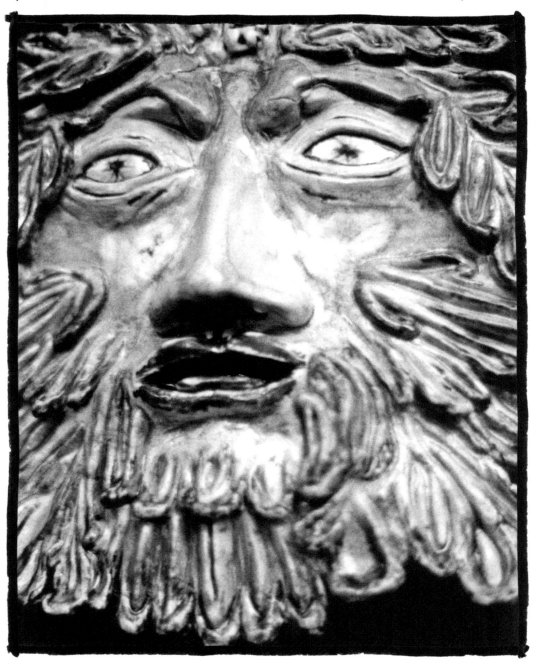

"HEY, AUDREY!" I said, "Let's go. I need rest."
We went in, but ZAP! ZAP! the sun stayed a pest!

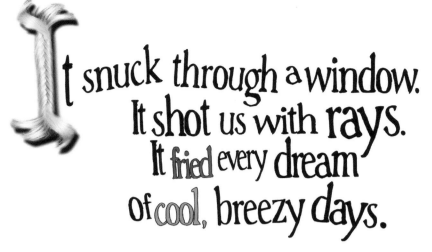

It snuck through a window.
It shot us with rays.
It fried every dream
of cool, breezy days.

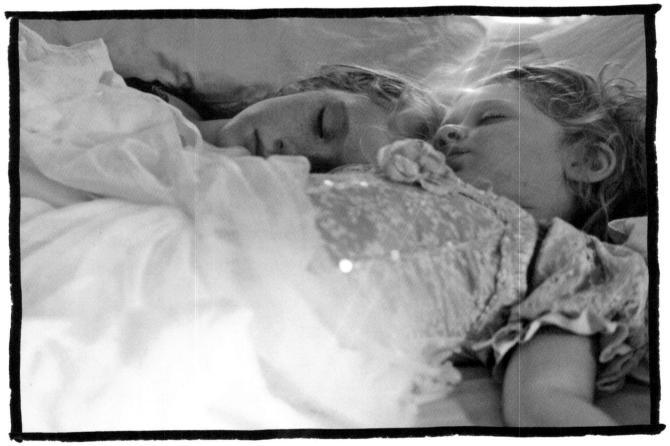

Our kindness - our sweetness
Then melted to gunk.
We sisters woke up
In a terrible funk.

With all sweetness gone and friendship forgotten,
Quite soon we were bad – Quite soon we were rotten.
Teatime was mean time. No sharing – No fun.
Aud filled cups and cups, but she let me fill none.

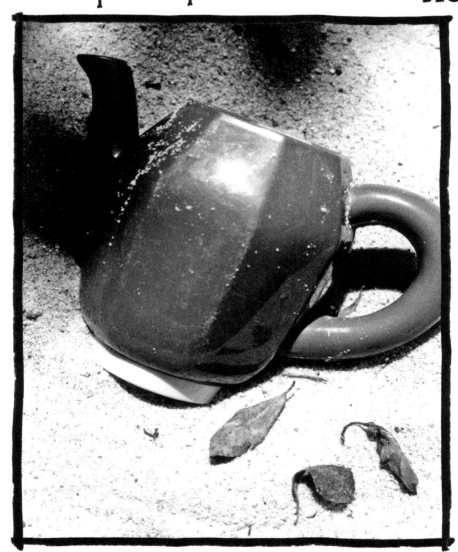

"HEY, AUDREY!" I said while that sun made me burn,
"Can I have the teapot? Can I have a turn?"
And LICKITY SPLIT, when I asked her to share ...

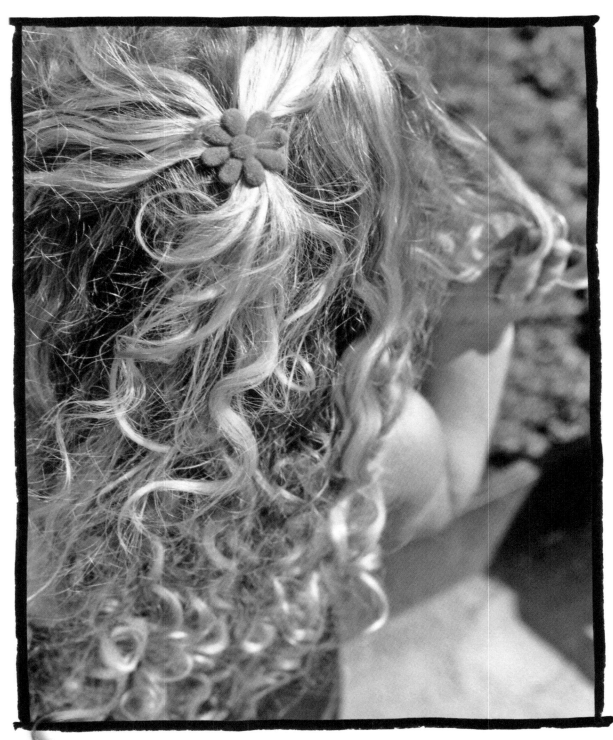

She yelled.
I screamed...
SHE PULLED MY HAIR!

"Ouch!" I cried. "That is my teapot too! You had best share it now or just see what I'll do!"

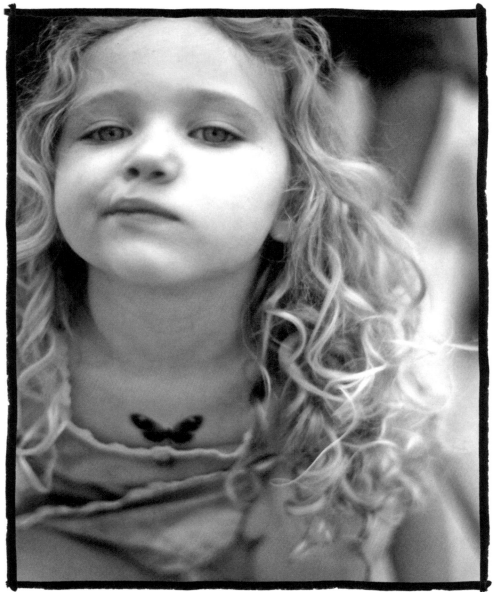

My sister snarked back, "It mine Beebee. Look it. My pot! My pot!" she teased... 'til I took it!

(Please reader know, my name is just Phoebe.
Audrey, however, always says Beebee.)

"BEEBEE, THE POT!" Aud yelled turning red.
When I kept filling the cups, she snarled and she said,
"I will tell on you BeeBee. Give teapot! YOU DO IT!"
I was so angry then that I gave it... I threw it!

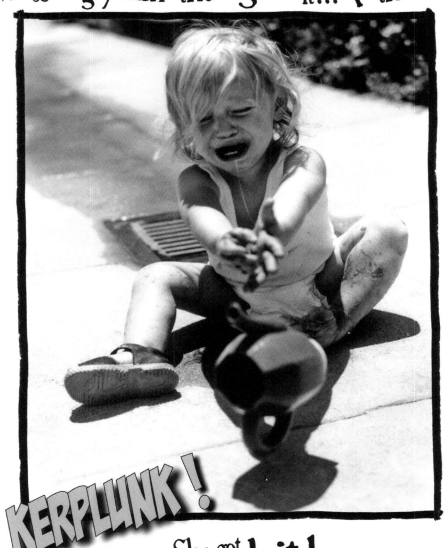

KERPLUNK!

She got hit!
The pot whacked her foot. I should have said sorry,
But I couldn't stay put.

'Cause **hot** on my heels *the* angry sun set—
I ran from its heat wave – The very worst yet.

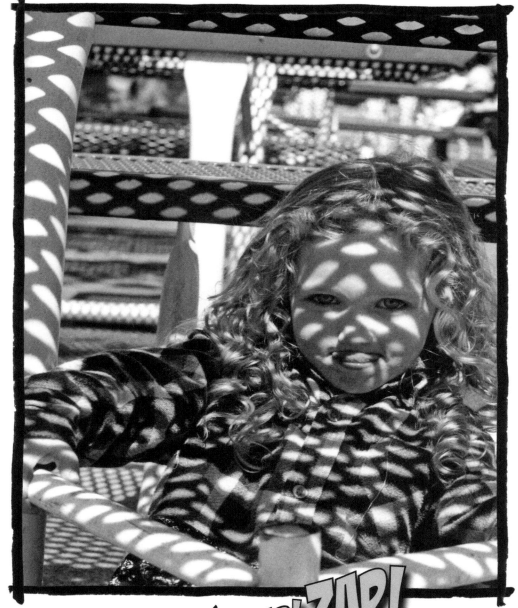

When I hid, I got spotted. ZAP! ZAP! the rays came
'Til I spotted a place where the sun could not aim.

I found a big tree. Its leaves blocked each ray.
As I cooled in its shade, I thought hard about my day.

Then loudly I said, "I WISH AUDREY WOULD SHARE!"
SWOOSH! blew the wind-SWOOSH! SWOOSH!
through my hair!

Many times I have wished for puppies-toys-cake,
But those wishes had never made everything shake!

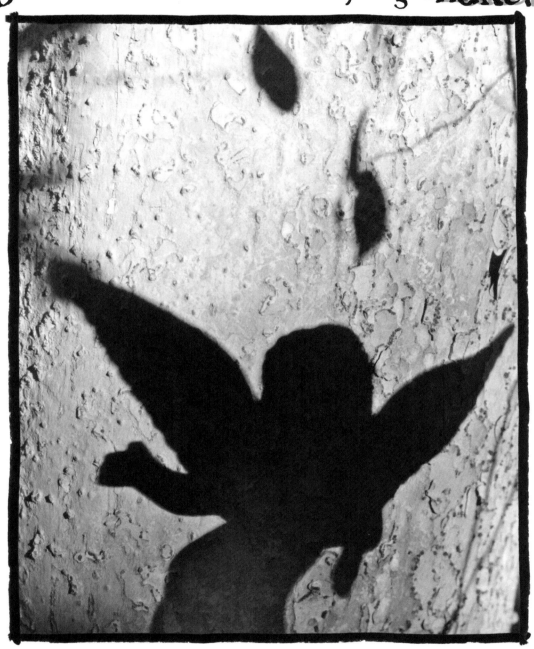

This wish got leaves rustling, and suddenly up high,
I saw a winged lady - it is true - she could fly!

"Dear Phoebe," she said. "I have a great sharing spell. It brings nice, new smiles and helps people play well."

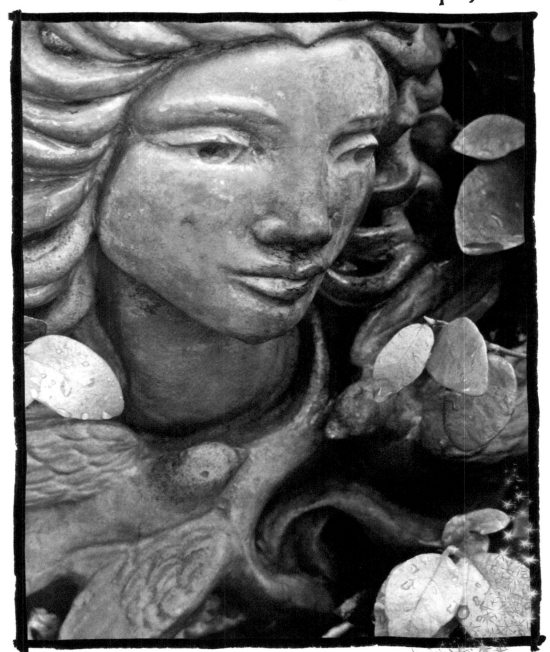

"From these leaves that you see on this magical tree, get one won't you please, and now listen to me."

"Wave the leaf at your sister. Say, 'this is for you.'"

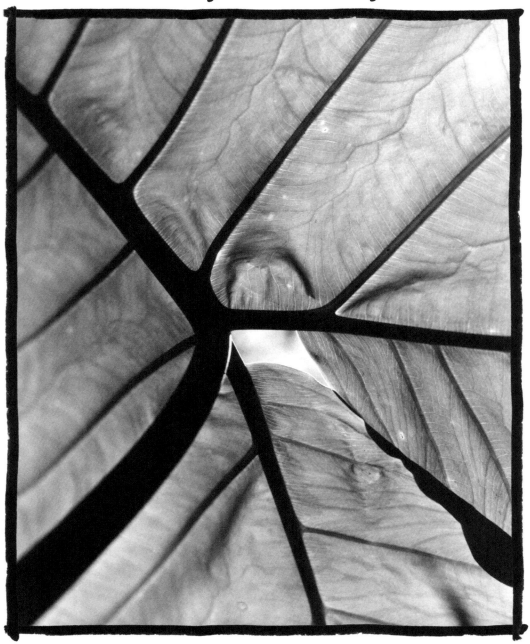

"Give the leaf and a kiss, And make sweetness anew!"

"**T**hat's it? **Easy-Peasy!**
I can make Audrey share!"

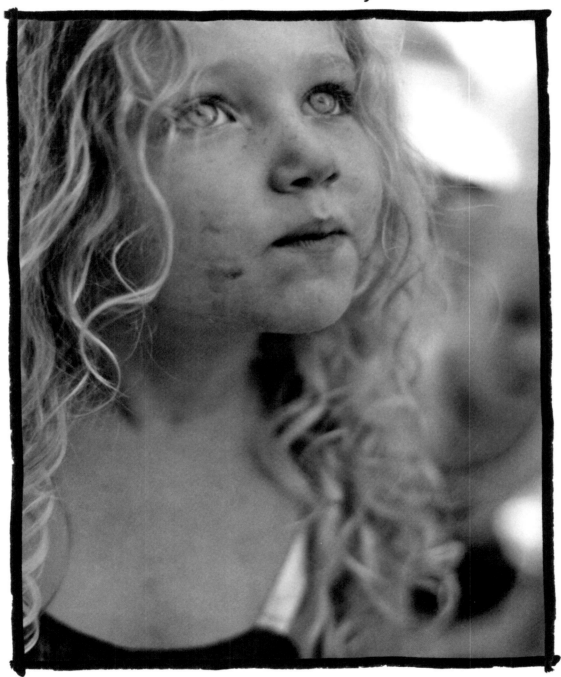

I thought, "When *I'm* home,
she'll be out of my hair!"

So off I went to find Aud. She was **mad** like before,
But this time her bunny was hearing her **roar.**

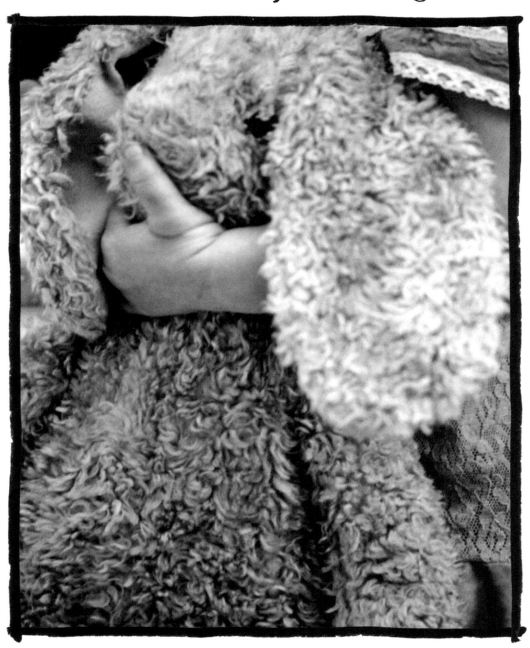

"G**rr**rr," Audrey said, "N🚗 CAR FOR WOO WABBIT!"
Yet I thought, "Easy-Peasy! That car-I shall have it!"

I said, "Aud, see this leaf?" I waved it with a swish.
"This leaf is for you," and I gave her a kiss!

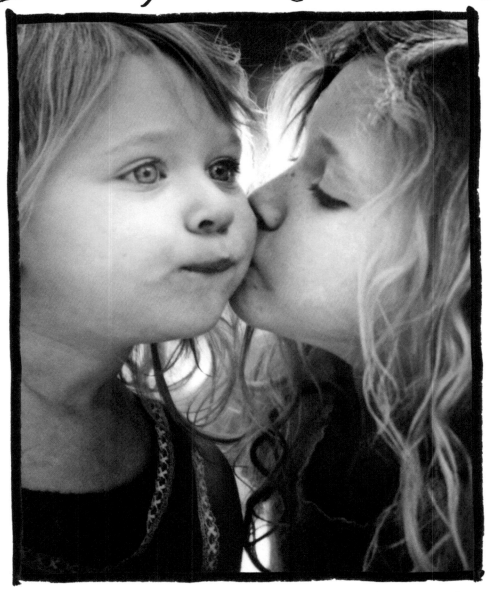

The leaf fanned away the sun's dreadful heat.
Magically, Aud smiled. It had worked.
She was sweet!

I then leaped into action. I gave it a go. I asked for the car, but my sister said, "NO!"

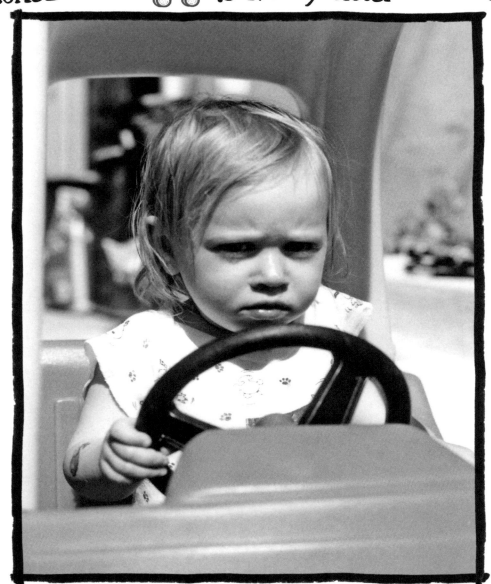

"HEY, AUDREY!" I said while the sun made me burn. "Can I have the car? Can I have a turn?" And LICKITY SPLIT, when again I said, "share... "

She yelled.
I screamed...
SHE PULLED MY HAIR!

I rushed to the tree.
"Tell me please what to do?"
Tree Lady said, "Phoebe, use leaf number two."

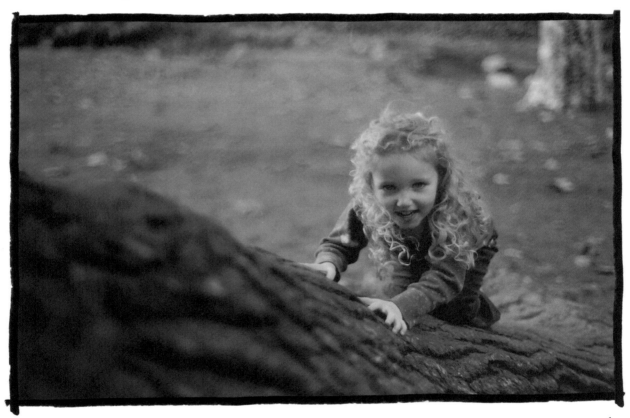

I took the leaf happily and waved it with swishes.
"This leaf is for you,"
I told Aud with kisses!

And oh how she smiled! It was more than before. Leaf two was SO strong, I would not need more.

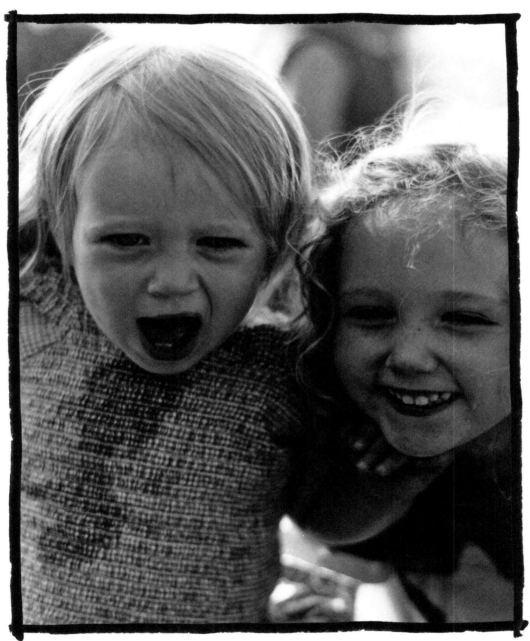

I waved it. I gave it. Easy Peasy! All done! My sis would soon share, and we soon would have fun!

"HEY, AUDREY!" I said while the sun made me burn.
"Can I have the bike? Can I have a turn?"

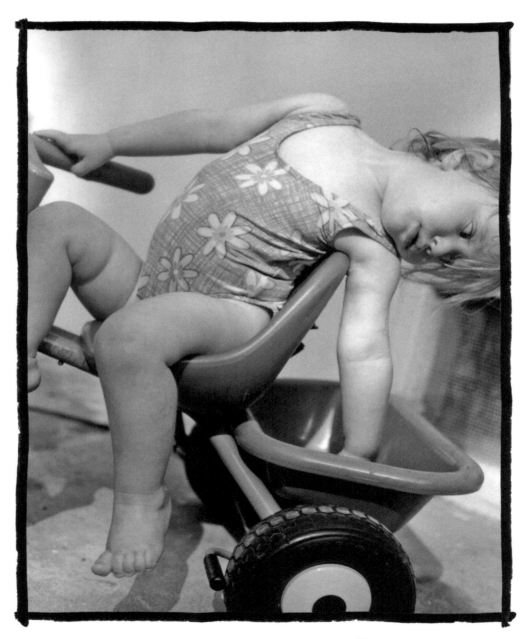

And LICKITY SPLIT,
When again I said, "share..."

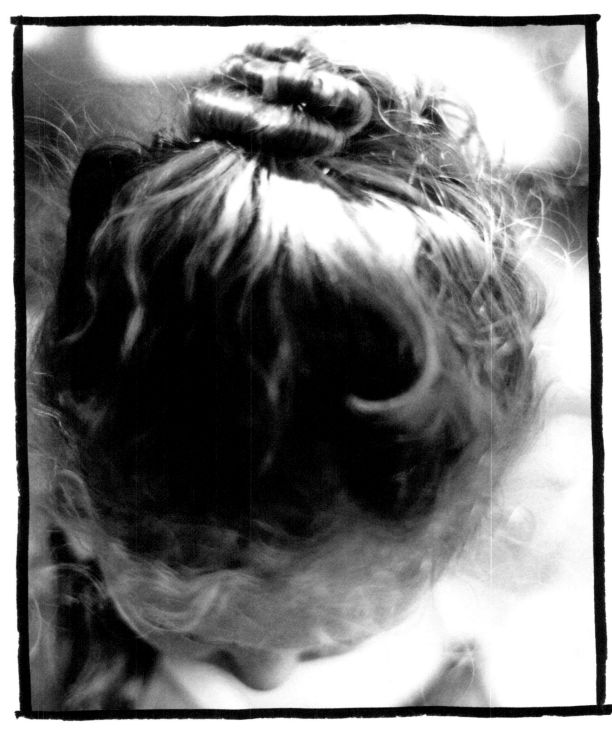

She yelled.
I screamed...
SHE PULLED MY HAIR!

Day after day – still more of the same;
Aud got the leaves, yet to me nothing came.

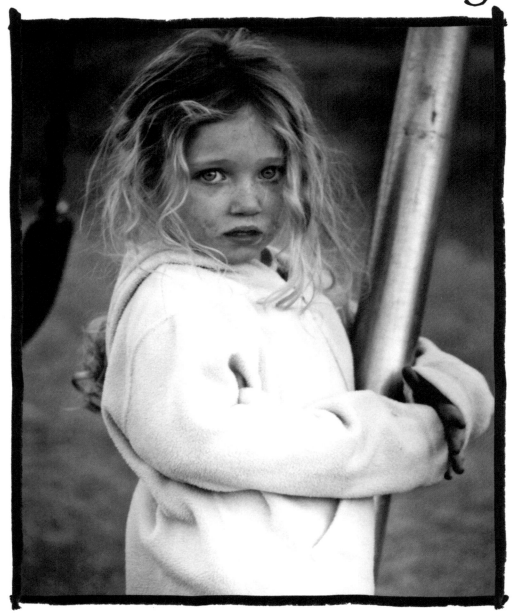

It was really unfair. I thought I would cry,
But the Tree Lady cheered, "Try again, Phoebe! Try!"

With my best smile on, I chose not to mope.
I turned over a new leaf, and I held on to hope.

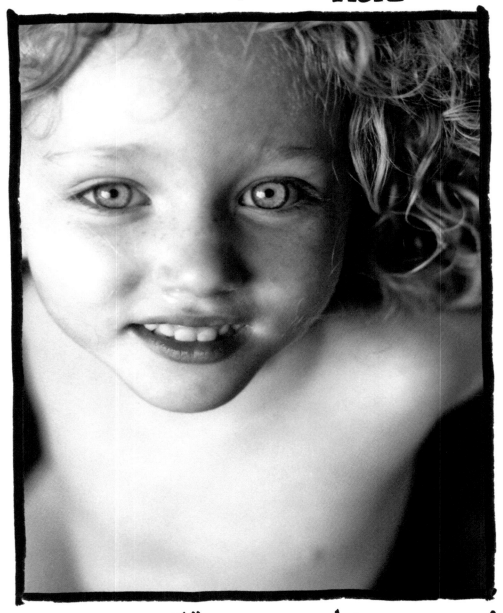

"HEY, AUDREY!" I said, swishing my swishes.
"This cool leaf is for you
With love and with kisses."

This time - success! Loud giggles - more fun.
I thought, "Easy Peasy! This leaf's the right one!"
"HEY, AUDREY!" I said. "Now show me you've learned.
Can I have the dolly? Can I have a turn?"

Well, she smiled and she gave it! She did not say, "NO!"
But then, as I took it, SHE-WOULD-NOT-LET-GO.
And LICKITY SPLIT, when again I said, "share..."

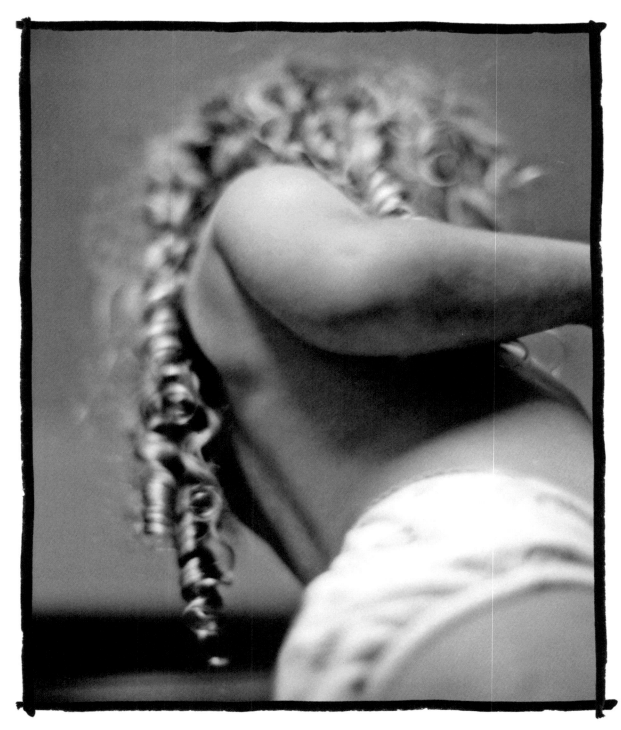

She yelled.
I screamed...
SHE PULLED MY HAIR!

Over and over she would not let things go.
Whatever I asked for, the answer was, "NO!"

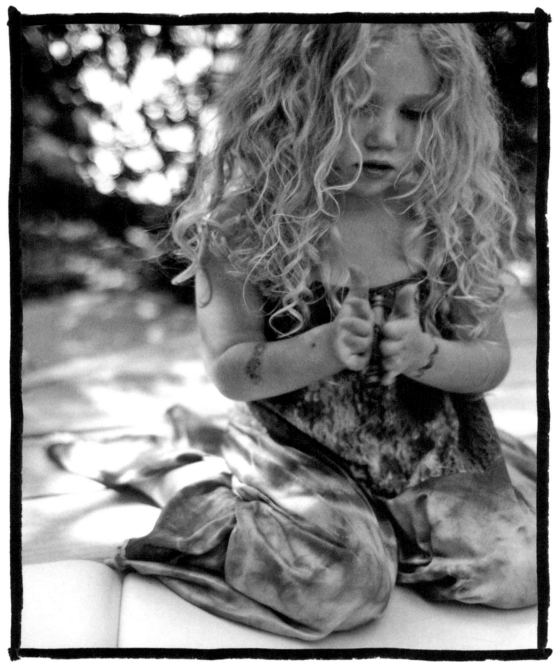

When summertime left, it left things the same.
I sat bored with a crayon, calling Aud's name.

"Hey, Audrey". *I sighed,* as the sun tried to burn.
"Can I have the marker?" sigh "Can I have a turn?"

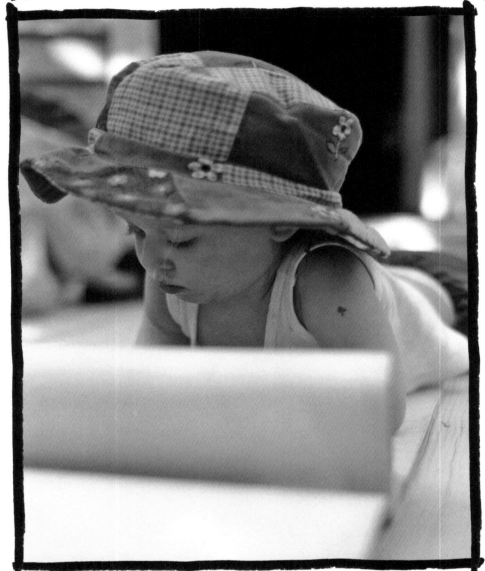

Above us the clouds came. It got cooler - darker.
Audrey stared down at the pink magic marker.
And LICKITY SPLIT,
My OWN little sis...

Said, "Beebee for WOO,"
And she gave me...

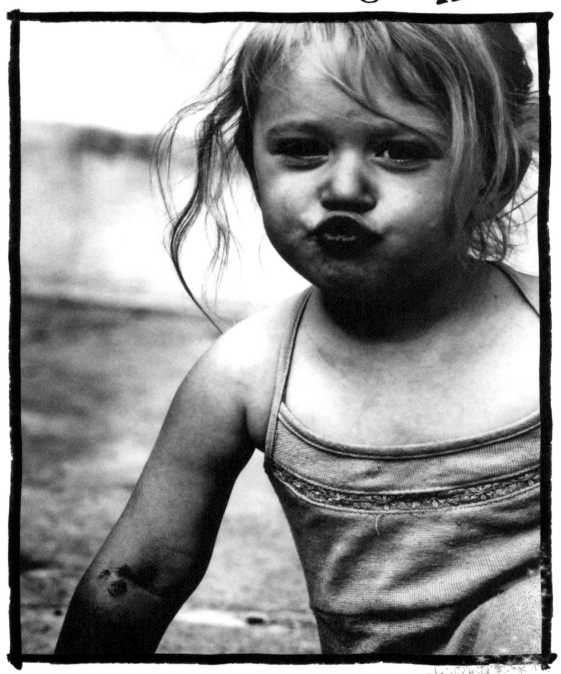

a Kiss!

"Oh thank you, Aud. THANKS!" I said with relief.
"This was not Easy-Peasy but sure worth every leaf."

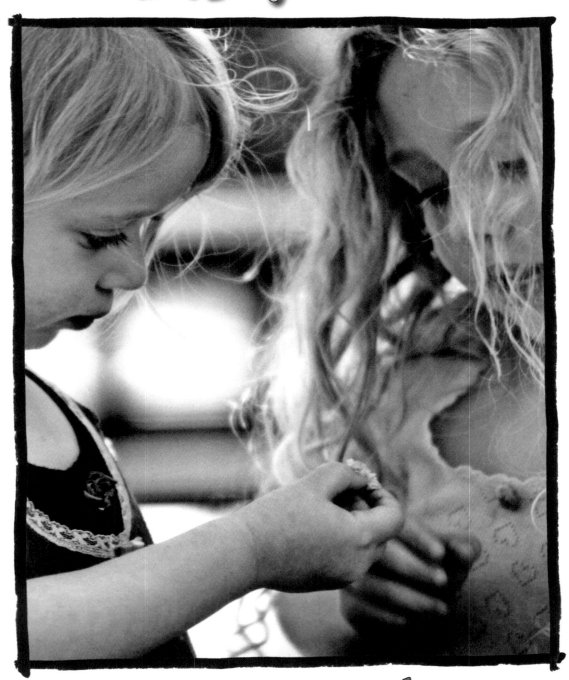

Then in fall I gave leaves with colors so bright
That Aud gave more too, and we two did not fight.

Brown, crunchy leaves by the handful **worked** faster. She **yelled**... for **joy!** I screamed...with **laughter!**

And guess who backed off and changed its bad mood? **G**uess who, at last, was not being **rude**? The **sun** with a grin sent rays without might. **O**n each **winter's** day we **enjoyed** its soft light.

Finally, the leaves were gone and not needed.
Tree Lady was happy her magic succeeded.

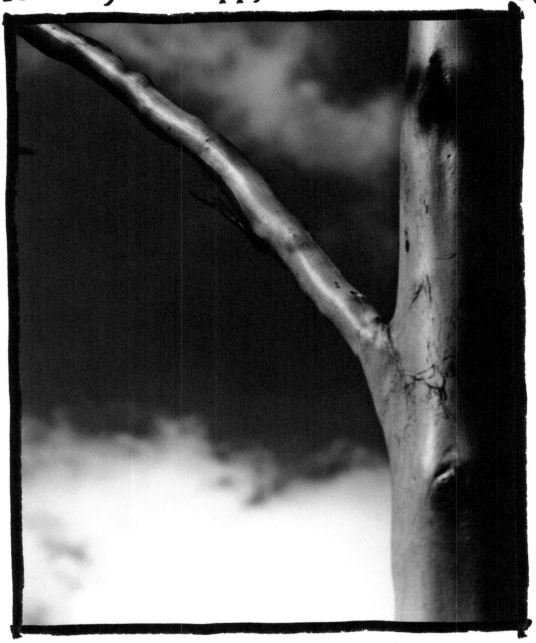

She rested 'til spring - her branches all bare.

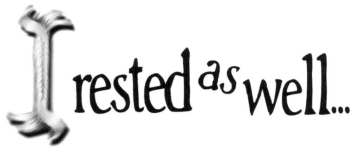

I rested as well...

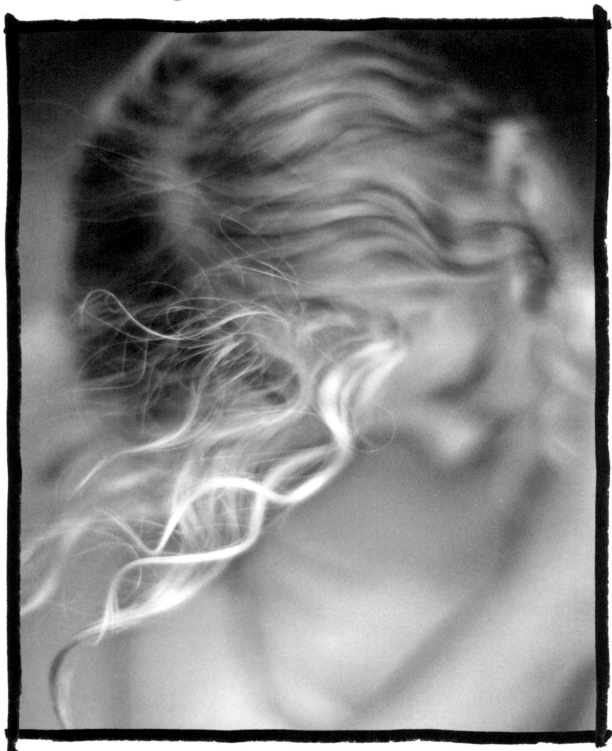

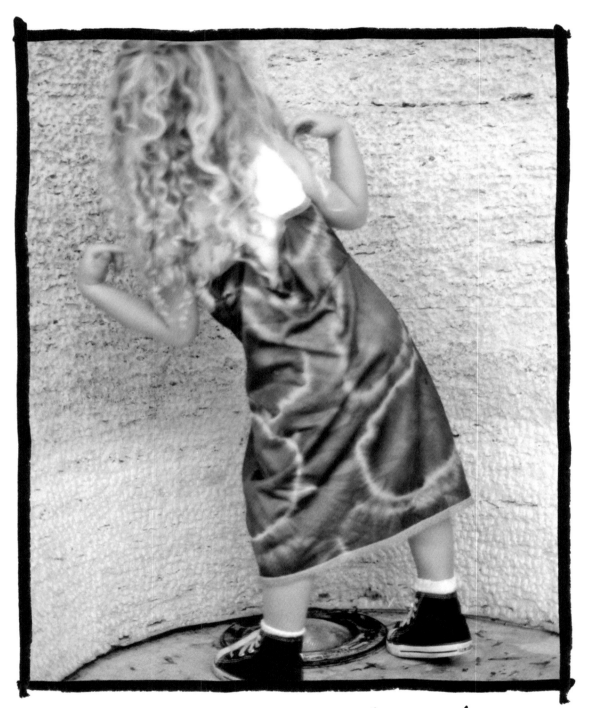

And so did my hair!

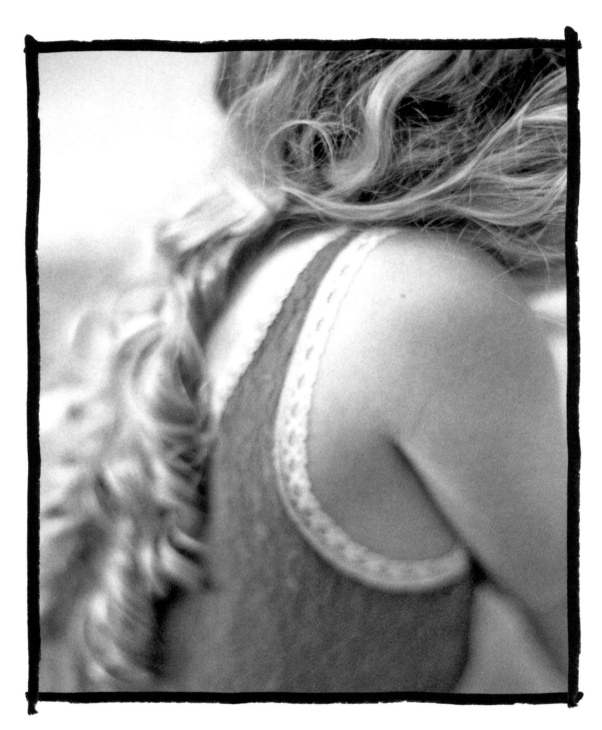

The end.

coming soon...
She yelled ice cream. We shared it!

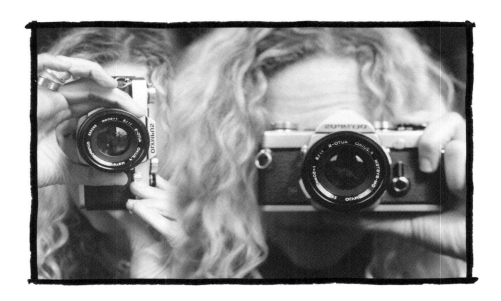

Tracy Leshay

I was born in New York. Soon after the birth of our second daughter, I arrived in California.
It was there I photographed our days in the sun, and spent nights in the dark processing them –
photographically that is – developer trays to the right of me – baby monitor to the left.

Becoming a children's book writer was never the plan, but a print series of
Phoebe's long locks sparked my imagination. As I went through my many negatives,
She Yelled. I Screamed...She Pulled my Hair found its beginning, middle and end.
It is the images that wrote this tale, and here they may offer readers of all ages
a glimpse into the wonderful world of black and white photography; a perfect format
for focusing on a subject while exploring contrast, shape, and form.

Every photograph was taken with my Olympus OM-1 35mm camera.
I have had this camera since I was very young but did not learn to use it back then.
Photography for me came later when two very colorful characters entered my life.
Quickly the camera was out of the bag and with me behind it ever since.

Currently I am at work on another Phoebe & Audrey tale and look forward to hearing from readers.
For the latest information, to share your thoughts, or simply share a book, please visit me at

tracyleshay.com

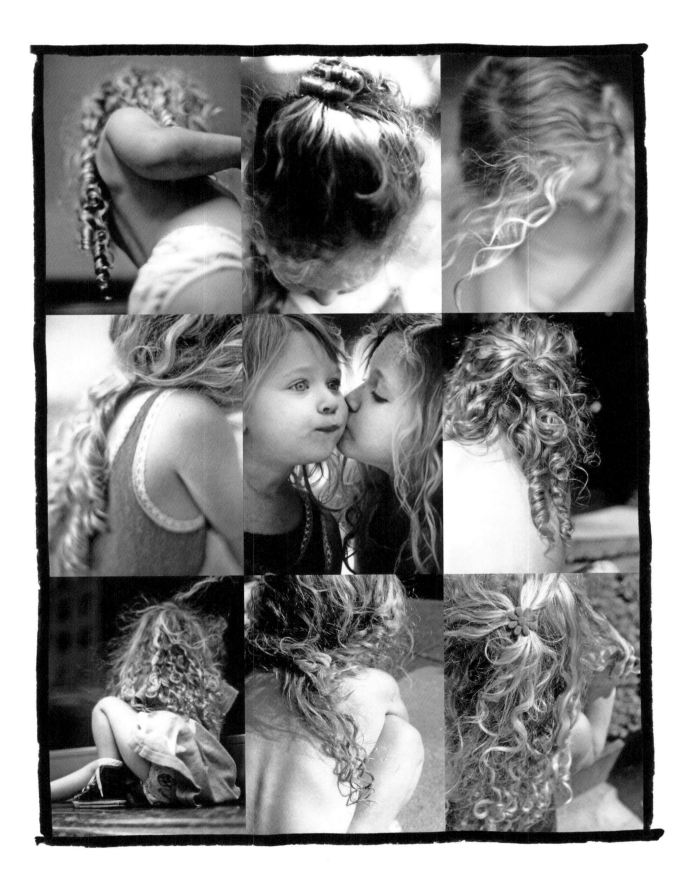

CPSIA information can be obtained at www.ICGtesting.com
Printed in the USA
LVIW01n2127290415
436663LV00007B/13